Step-by-Step

Paperfolding

Clive Stevens

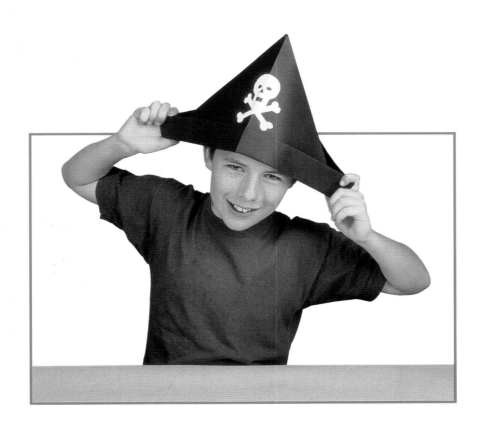

Search Press

First published in Great Britain 2001

Search Press Limited
Wellwood, North Farm Road,
Tunbridge Wells, Kent TN2 3DR

Reprinted 2002, 2003, 2004, 2005

Text copyright © Clive Stevens 2001

Photographs by Search Press Studios
Photographs and design copyright © Search Press Ltd. 2001

ISBN 0 85532 908 4

Suppliers
If you have difficulty in obtaining any of the materials and equipment mentioned in this book, then please visit the Search Press website for details of suppliers:
www.searchpress.com

Alternatively, you can write to the Publishers at the address above, for a current list of stockists, which includes firms who operate a mail-order service.

Acknowledgements
The Publishers would like to thank the Bridgeman Art Library for permission to reproduce the photograph on pages 4-5.

Colour separation by Graphics '91 Pte Ltd., Singapore
Printed in China by WKT Company Ltd

To my daughter Angie, who I know will enjoy sharing all of the projects in this book with her young pupils.

Special thanks to G F Smith & Son London Ltd., 2 Leathermarket, Weston Street, London SE1 3ET for supplying the paper in this book. Many thanks are also due to everyone at Search Press who helped me with this book, especially Editorial Director Roz Dace and Editor Chantal Roser for their help and guidance, and Designer Tamsin Hayes for putting it all together.

The Publishers would like to say a huge thank you to Joe Clarke, Tom Clarke, Natasha Nokes, Lloyd Perry, Gilly Armour, Caroline Armour and Christopher Armour.

Special thanks are also due to Southborough Primary School, Tunbridge Wells.

When this sign is used in the book, it means that adult supervision is needed.

REMEMBER!
Ask an adult to help you when you see this sign.

Contents

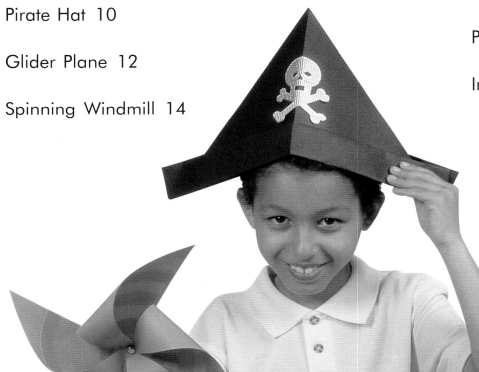

Introduction

Paperfolding is not only an ancient art, but it is one that requires very little equipment or space. As long as you have paper, a pair of scissors and some glue you can create a variety of wonderful sculptural shapes.

The art of paperfolding is thought to date back to the first or second century AD in China. The Japanese were practising this art by the sixth century and they called it origami (pronounced or-i-GA-me). The word is made up from 'ori', the Japanese word for folding, and 'kami', the word for paper.

In Japan, paper was scarce long ago, so only wealthy people could afford to do paperfolding. But as easier methods of papermaking were developed, paper became less expensive and paperfolding became a popular art for everyone.

The Japanese were not the only people folding paper. The Moors from North Africa were also practising this art. Their religion forbade the creation of representational figures, so their paperfolding took the form of geometric decorative designs, and they took their techniques with them when they invaded Spain during the eighth century. From there, paperfolding spread to South America, then to other parts of Europe as trade routes opened up, and later it spread to the United States. In Victorian England, it became a popular children's pastime. Paper hats, similar to the square

hat worn by the carpenter in Lewis Carroll's *Alice Through the Looking Glass*, were made.

In this book you begin with basic scoring and folding techniques, then go on to enjoy making a pirate hat, a glider plane, an animal mask and many other exciting

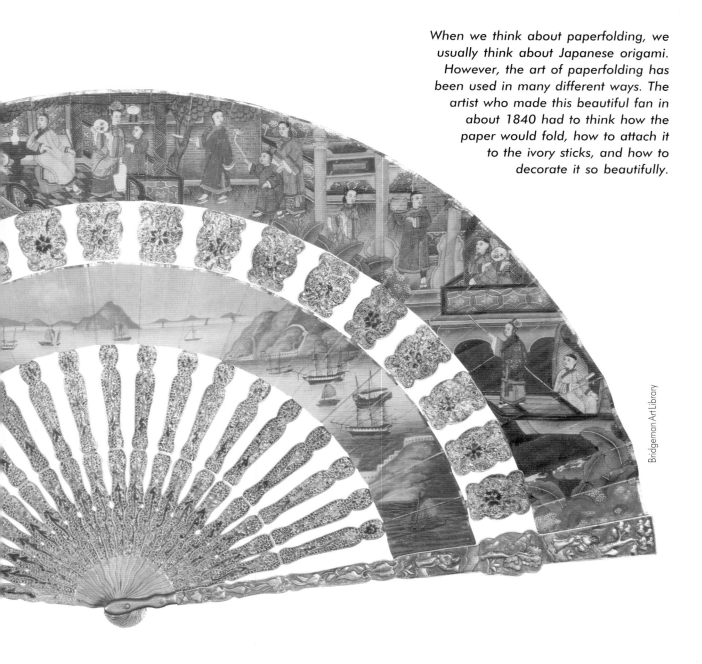

When we think about paperfolding, we usually think about Japanese origami. However, the art of paperfolding has been used in many different ways. The artist who made this beautiful fan in about 1840 had to think how the paper would fold, how to attach it to the ivory sticks, and how to decorate it so beautifully.

Bridgeman Art Library

projects. You can also have fun designing and creating your own ideas. Be inventive by using different textured paper like thin corrugated card, brown wrapping paper, metallic and handmade paper. Or try using patterned paper such as gift wrap, wallpaper or pages from a magazine.

With paperfolding you can create wonderful greetings cards for your friends and family and design interesting gift wrap for a special present. So, have fun – and happy paperfolding!

Materials

The best thing about paperfolding is that it does not cost much to get started. You will not need all the materials shown on this page to begin, and you may already have some of them at home. Other items are easy to buy from local shops. In addition, there are some specific items needed for certain projects, such as cotton thread, a brass split pin, a paper clip, clear sticky tape and a coat hanger. You should check the list of materials carefully before you start each project.

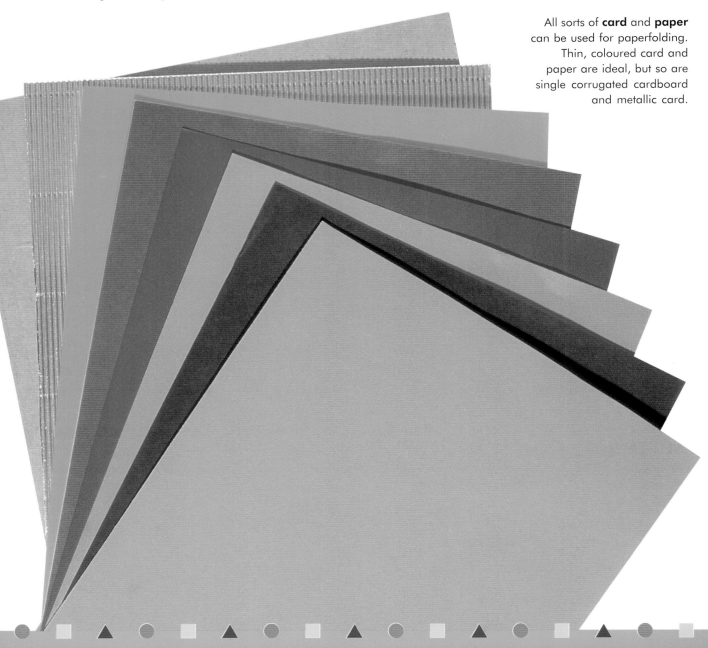

All sorts of **card** and **paper** can be used for paperfolding. Thin, coloured card and paper are ideal, but so are single corrugated cardboard and metallic card.

A **ballpoint pen** that has run out of ink is used to score paper or card. Alternatively, you could use an embossing tool, or any other blunt instrument.

Scissors are used to cut out card, paper and cardboard.

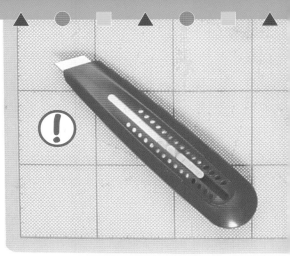

A **craft knife** is used to cut out intricate designs and to make small slits. Always ask an adult to do this for you as it is very sharp. A craft knife should always be used on a **cutting mat**.

A **black marker pen** is used to add detail to projects.

Strips of card are secured with a **stapler.**

Tracing paper, **carbon paper** and a **pencil** are used when transferring designs. **Masking tape** should be used to hold the designs in place.

PVA glue is used to stick surfaces together. Double-sided tape can be used instead of glue. It is more fiddly to use but it can prevent the paper and card from distorting.

A **ruler** is used for measuring and for scoring straight lines.

Techniques

There are several basic paperfolding techniques. Freehand folding is simply folding paper without scoring or measuring the paper or card. To create intricate shapes it is helpful to score the paper or card first with a blunt instrument. Folding away from you makes a valley fold. Folding towards you makes a mountain fold. These are shown in the patterns as dots and dashes for valley folds, and dashes for mountain folds (see page 28).

Scoring straight lines

Place a ruler on the piece of card, where you want the line to be. Use the ruler as a guide and run an empty ballpoint pen along the edge to make an indent in the paper.

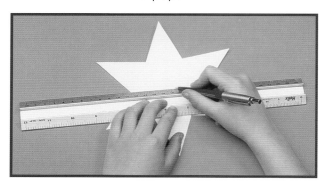

Scoring curves

Cut out a cardboard template of the shape you need. Run an empty ballpoint pen along the edge of the template to make an indent in the paper. Alternatively, you can score a curve freehand.

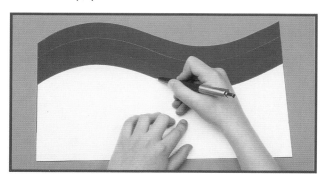

Hard-folding

Fold the card over along the line you have scored. To hard-fold, use the side of your finger-nail to make a neat fold along the scored line.

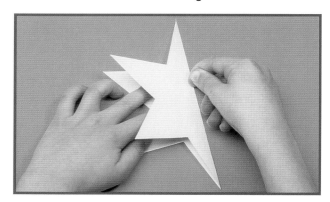

Soft-folding

Gently pinch along the scored line with your fingers. Repeat several times.

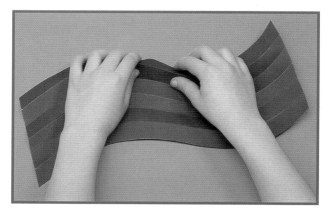

Making a template

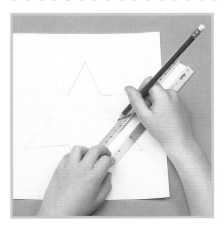

1

Place a piece of tracing paper over the pattern (see pages 28-31). Tape it down with small pieces of masking tape. Trace around the outline using a pencil. You can use a ruler if the pattern has straight lines. Remove the tape from the tracing paper.

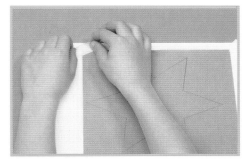

2 Place a piece of carbon paper face down on the surface you want to transfer the design on to. Place the tracing over the top then tape it in place.

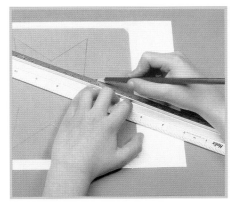

3 Trace around the outline with a pencil. Again, use a ruler for any straight lines.

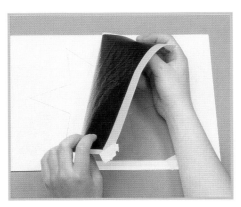

4 Remove the tracing paper and carbon paper to reveal the transferred image.

Pirate Hat

This project only requires simple freehand folding and it is an age-old favourite. It was popular with Victorian children when they played at being pirates. The hat can be embellished by attaching cut-out designs, such as a skull and crossbones, or you could attach a feather if you want to make a Robin Hood hat.

YOU WILL NEED

Black paper
Thin metallic card
Tracing paper • Carbon paper
Masking tape • Pencil
Scissors • Craft knife
Cutting mat • PVA glue

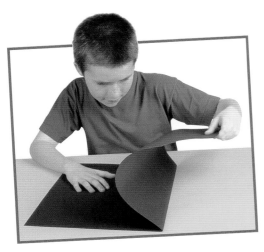

 1 Take a piece of black paper, the same size as an unfolded tabloid newspaper, and hard-fold it in half lengthways (see page 8).

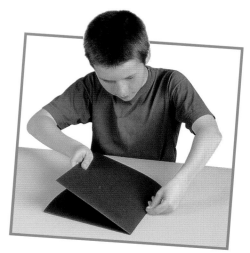

2 Hard-fold the paper in half lengthways again.

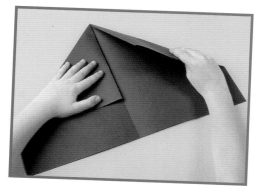

3 Open up the last fold, then fold down the left-hand corner to the centre line. Repeat with the other corner.

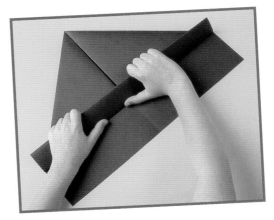

 4 Fold up the bottom edge nearest to you so that it meets the corners. Fold it up the same amount again. Turn the hat over and repeat on the other side.

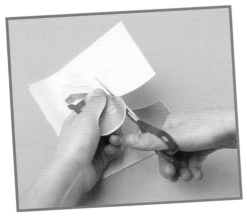

5

Trace the skull and crossbones pattern shown on page 31 on to metallic card (see page 9). Use scissors to cut out the main shape, and a craft knife to cut out the small shapes inside.

Craft knives are very sharp. Ask an adult to cut out the small shapes.

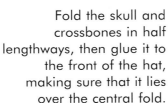
6

Fold the skull and crossbones in half lengthways, then glue it to the front of the hat, making sure that it lies over the central fold.

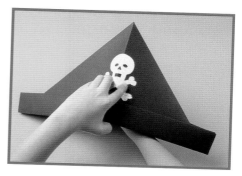

FURTHER IDEAS

Make a Robin Hood hat using different coloured paper. Using scissors, cut out a feather shape from card, score it down the middle then cut lots of slits in it.

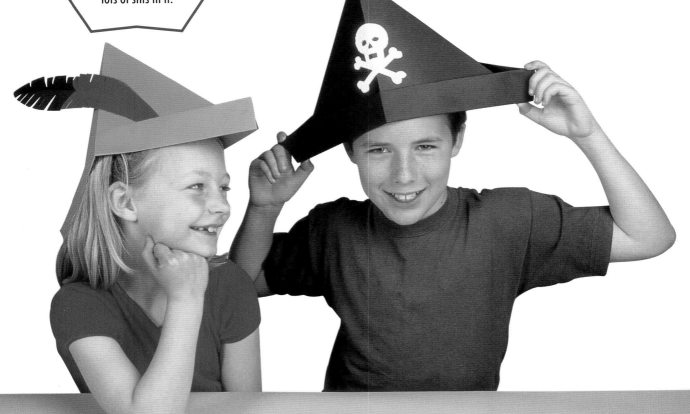

Glider Plane

Your mother or father may have folded wonderful paper aeroplanes for you when you were younger. Well, here is one that you can easily make yourself, using freehand folding, soft-folding and one piece of coloured paper. The plane is decorated with cut-out thin coloured paper shapes which are glued on to the wings. You should never launch your finished plane towards other people.

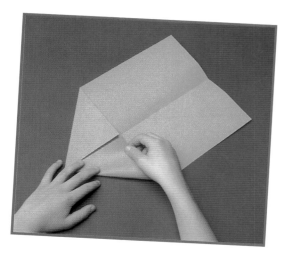

1 Cut a piece of coloured paper approximately 25cm x 28cm (8½in x 11in). Score and soft-fold it in half lengthways (see page 8), then fold the top corners down to the centre line.

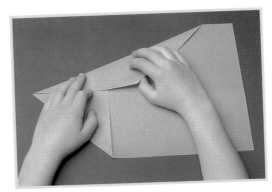

2 Fold each side in from the point, to meet the centre line.

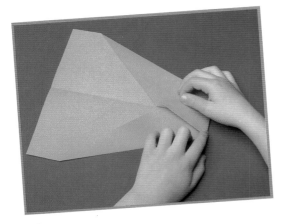

3 Fold the tip back towards the middle, to the point where the sides meet to form the front of the plane.

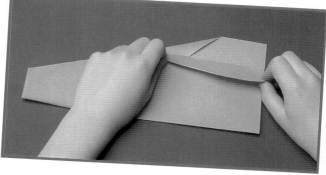

4 Fold the plane in half lengthways, then fold the top wing down about 1cm (½in). Turn the plane over and repeat on the other wing.

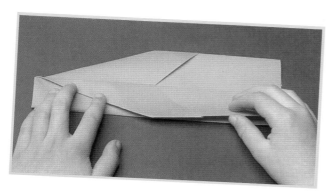

5 Fold the wing down again, from the top of the nose. Turn the plane over and repeat on the other wing.

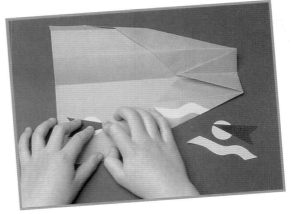

6 Flatten the plane out. Cut out your own decoration from coloured paper, then glue the shapes on to the wings.

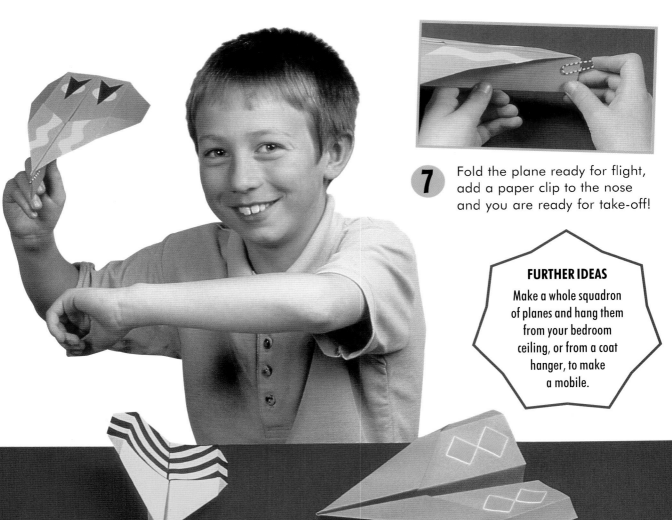

7 Fold the plane ready for flight, add a paper clip to the nose and you are ready for take-off!

FURTHER IDEAS

Make a whole squadron of planes and hang them from your bedroom ceiling, or from a coat hanger, to make a mobile.

Spinning Windmill

This simple design is made from brightly coloured thin card and decorated with different size dots in a contrasting colour. When the windmill spins, it forms wonderful coloured patterns. The handle is made by scoring lines along a length of thin card which is folded into a triangular stick.

YOU WILL NEED

Coloured paper
Thin card • Empty ballpoint pen
Ruler • Pencil • Scissors
PVA glue • Craft knife
Cutting mat
Brass split pin

1 Cut out a piece of coloured paper approximately 20cm (8in) square. Cut out some shapes from a different coloured paper and glue them on to the square.

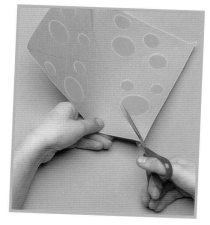

2 Use a ruler and pencil to draw two diagonal lines through the square to form a cross. Make a cut at each corner, exactly one third of the way along the pencil line.

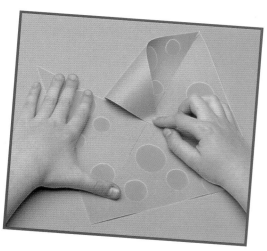

3 Pull one of the points down just past the centre and glue it in place. Hold it for a few moments until it is dry. Repeat with the other three points.

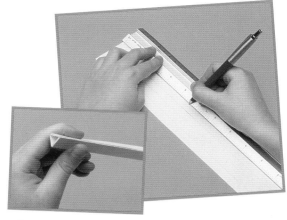

4 Cut out a rectangle of thin card, 4cm x 30cm (2in x 11¾in). Mark and score three lines 1cm (½in) apart. Fold along the lines, then form the card into a triangular stick. Glue in place and hold until dry.

14

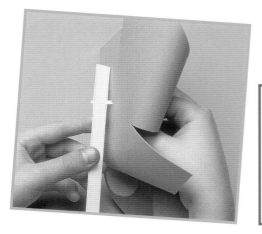

Craft knives
are very sharp.
Ask an adult to
cut the small
slit in the stick
for you.

5 Use a craft knife to cut a very small slit in one end of the stick approximately 2cm (¾in) from the end. Make sure that it goes all the way through to the other side. Using scissors, cut a small hole in the centre of the windmill; push a split pin through it, then through the paper stick.

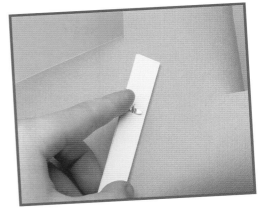

6 Carefully fold back the ends of the split pin, so that the windmill can turn.

FURTHER IDEAS
Make some colourful miniature windmills, tape them to cocktail sticks, then display them in a small vase or container.

Twisted Pot

With simple folds you can create some colourful crazy containers – and this ingenious little twisted pot is a wonderful example of cardboard engineering. You can decorate it with paper shapes, then fold and glue it to form a square box shape. With a simple twist it suddenly springs to life.

YOU WILL NEED

Thin coloured card
Coloured paper
Tracing paper • Carbon paper
Masking tape • Pencil
Empty ballpoint pen
Scissors • Ruler
PVA glue

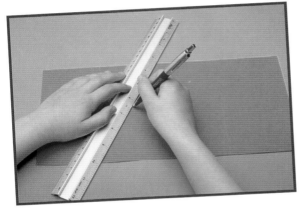

1 Transfer the design shown on page 30 on to thin coloured card (see page 9). Cut out the rectangular shape. Score the card along the vertical and diagonal lines using an empty ballpoint pen and a ruler (see page 8).

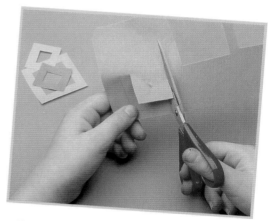

2 Cut out shapes of your choice from coloured paper.

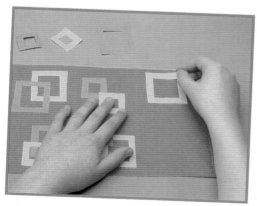

3 Use PVA glue to stick the paper shapes to the card. Leave to dry.

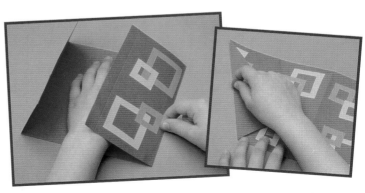

4 Hard-fold along all of the scored lines (see page 8). Turn the card pattern face-down and fold the vertical lines towards you. Turn the card over then fold the diagonal lines towards you.

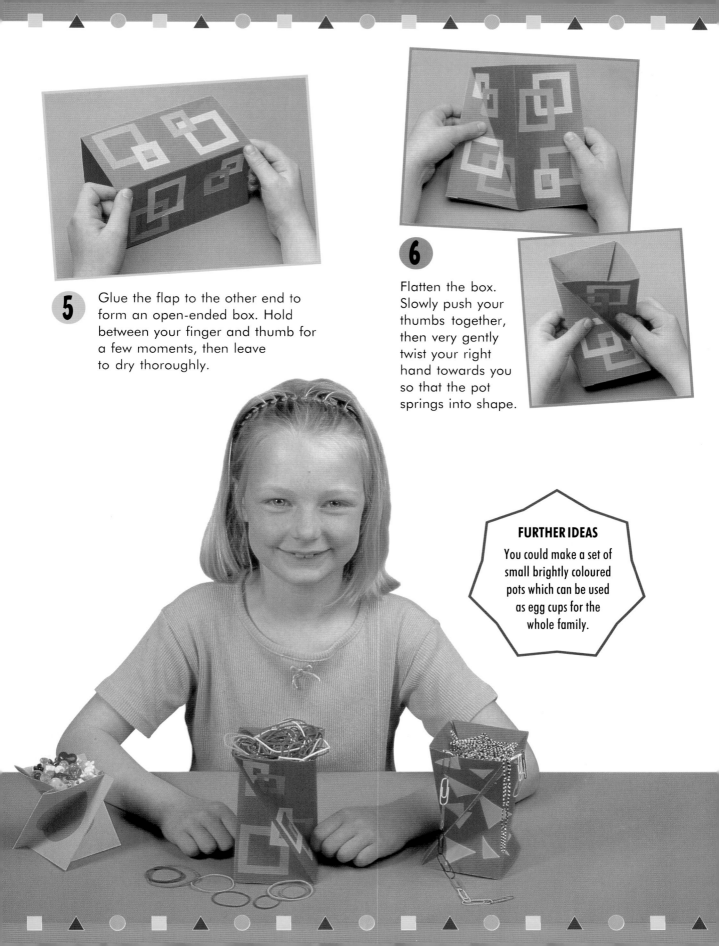

5 Glue the flap to the other end to form an open-ended box. Hold between your finger and thumb for a few moments, then leave to dry thoroughly.

6 Flatten the box. Slowly push your thumbs together, then very gently twist your right hand towards you so that the pot springs into shape.

FURTHER IDEAS
You could make a set of small brightly coloured pots which can be used as egg cups for the whole family.

Bat Mobile

This fun mobile uses black and contrasting metallic card, so that when the stars and moon turn they reflect the light beautifully. The shapes are traced from the patterns, cut out and scored to create a three dimensional image. They are then suspended by thread on a coat hanger, but you could use an ordinary wooden stick or a wire rod.

YOU WILL NEED

Black and thin metallic card
Tracing paper • Carbon paper
Masking tape • Pencil
Scissors • Empty ballpoint pen
Ruler • Sharp pencil
Cotton thread • Clear sticky tape
Coat hanger

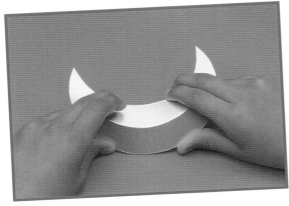

1 Transfer the bat, moon and star patterns from page 29 on to black and thin metallic card (see page 9). Cut out the shapes.

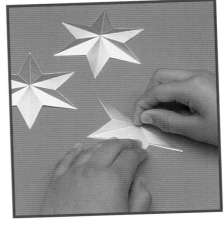

2 Score and then hard-fold the stars (see page 8) then open them up to form three-dimensional forms.

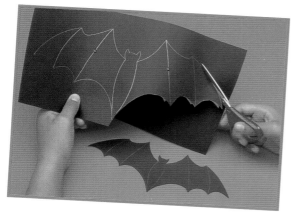

3 Score along the curved centre line of each moon and then soft-fold gently (see page 8).

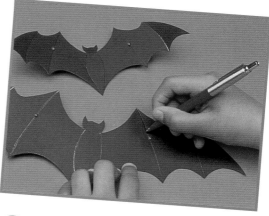

4 Score each bat freehand, then soft-fold to give shape to the body and wings.

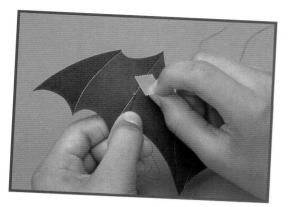

5

Thread lengths of cotton through the holes and secure on the underside with clear sticky tape.

Ask an adult to help you suspend your mobile from a suitable location.

Note You can adjust the way your mobile hangs by adding small pieces of removable adhesive to the pieces.

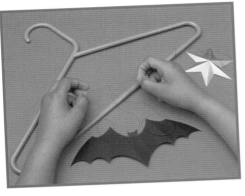

6 Tie the cotton on to a coat hanger to suspend the moon, stars and bats at different levels. Snip off any loose ends.

FURTHER IDEAS

You could cover the coat hanger with crepe paper. Decorate it with cut-out cloud shapes or shiny stars.

Pleated Picture Frame

Every artist needs a beautiful frame for a favourite picture or painting. It completes the effect and complements the image it surrounds. This project shows you how to create a simple pleated frame. The sides are glued on to a corrugated cardboard base and pleated corners are added in a contrasting colour.

YOU WILL NEED

Single corrugated cardboard
Thin coloured card
Scissors • Ruler
Empty ballpoint pen
Tracing paper • Carbon paper
Masking tape • Pencil
PVA glue

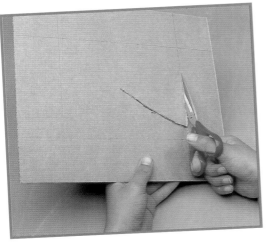

 Cut out a piece of corrugated cardboard 22cm x 25cm (8¾in x 10in). Draw a line 5cm (2in) in from each edge with a ruler and pencil. Cut out the centre to form a frame.

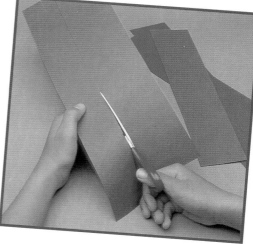

2 Cut out 2 strips of thin coloured card 6cm x 30cm (2¼in x 11¾in) and 2 strips 6cm x 27cm (2¼in x 10¾in).

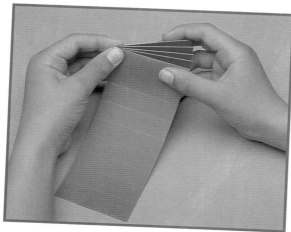

3 Mark lines 1.5cm (⅝in) apart all along each strip of coloured card. Pleat each strip by scoring and then hard-folding along the lines (see page 8).

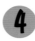

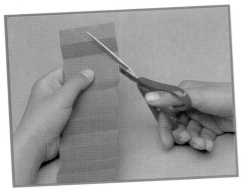

4

Open the pleated strips out. Mark a diagonal line from the third fold approximately 1cm (½in) in from the corner. Cut the corner off. Repeat on all ends of the coloured card strips.

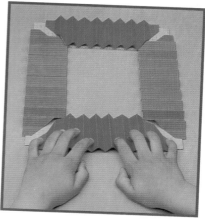

6

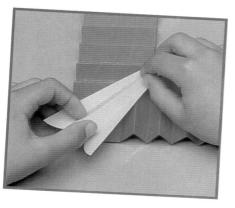

Transfer the pattern on page 29 on to coloured card four times (see page 9). Cut them out, score and pleat them, then glue them on to each corner to hide the joins.

5

Apply glue to the cardboard base, then position the pleated strips on top. Leave to dry.

FURTHER IDEAS

You can use circles or other shapes on the corners, and experiment with different sized pleats to create different effects.

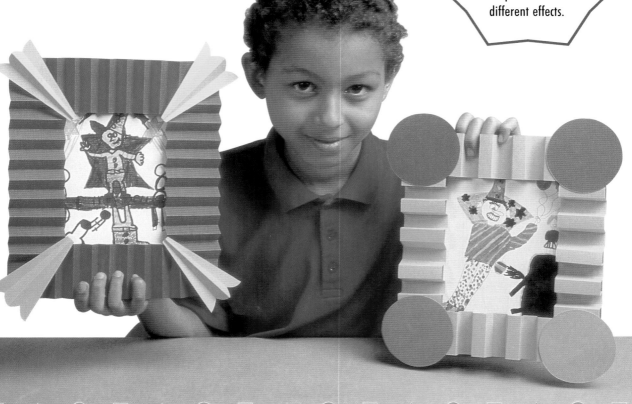

Bird and Worm Card

It is always nice to receive and send homemade cards. This pop-up card will amuse your family and friends and it can be used for any occasion. It uses a simple fold to create the pop-up action. The bird's head is transferred from the pattern and glued to the card. A slit is then cut along the beak and folded back. For the finishing touch a pink worm is added to the inside of the beak.

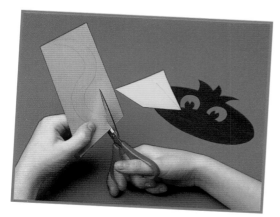

1 Transfer the bird and worm patterns on page 29 on to coloured paper (see page 9). Cut out the shapes.

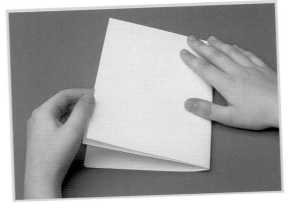

2 Cut out a piece of thin card approximately 36cm x 26cm (14¼in x 10¼in). Fold the card in half, and then in half again.

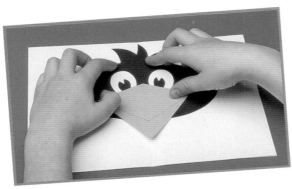

3 Unfold the card once and lay it flat, with the first fold at the top. Glue the beak on to the bird, then glue the bird on to the inside of the open card.

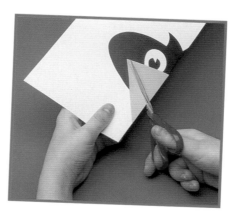

4 Open the card up completely. Fold it inside out and cut a slit along the line on the beak.

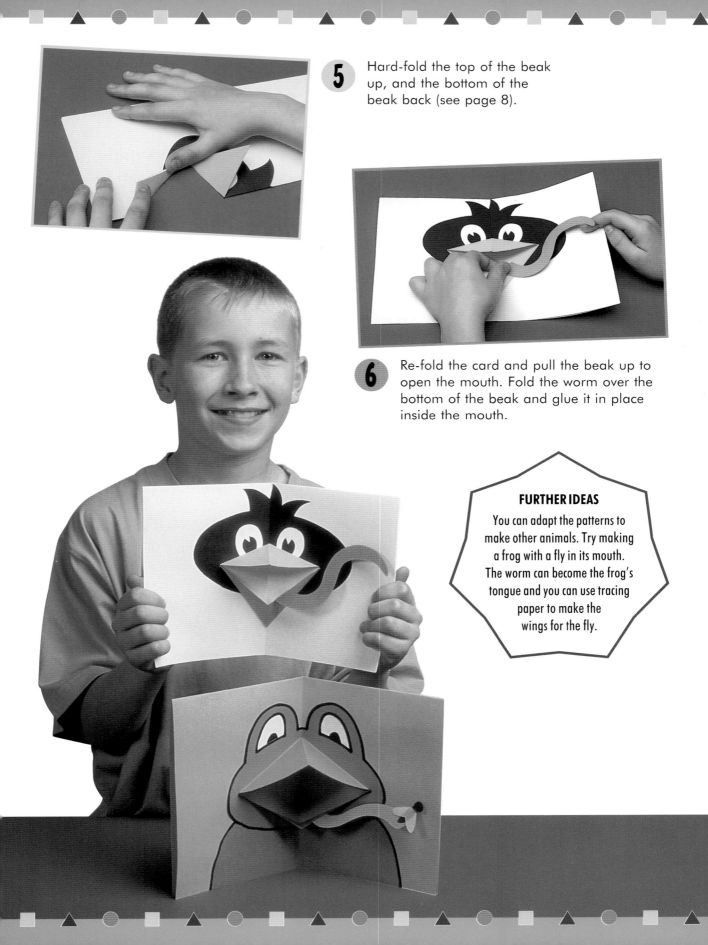

5 Hard-fold the top of the beak up, and the bottom of the beak back (see page 8).

6 Re-fold the card and pull the beak up to open the mouth. Fold the worm over the bottom of the beak and glue it in place inside the mouth.

FURTHER IDEAS
You can adapt the patterns to make other animals. Try making a frog with a fly in its mouth. The worm can become the frog's tongue and you can use tracing paper to make the wings for the fly.

Treasure Chest

Everyone has a collection of different things that they treasure and want to keep safe or hidden away. It could be special pebbles, shiny beads or secret messages. This little treasure chest is just the thing to store them in. It is made to look like the real thing by using a black marker pen to add the bolt heads and a lock.

YOU WILL NEED

Thin coloured card
Metallic paper
Empty ballpoint pen
Black permanent marker pen
Ruler • Tracing paper
Carbon paper • Masking tape
Pencil • Scissors
PVA glue

1 Transfer the basic chest pattern on page 28 on to thin coloured card (see page 9). Cut out the shape, then cut along the solid cut lines.

2 Score and hard-fold along all the dotted lines (see page 8).

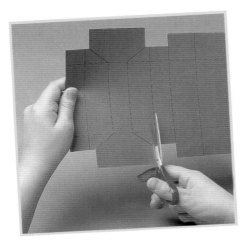

3 Glue the back of the angled tabs 1, 2, 3, 4 to the inside of the lid ends. Now glue tabs 5, 6, 7, 8 to the inside of the lid ends in the same way, to complete the lid

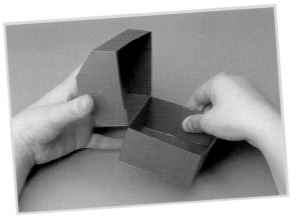

4 Glue the back of the corner tabs 9, 10, 11 and 12 to the inside of the base ends to form a box.

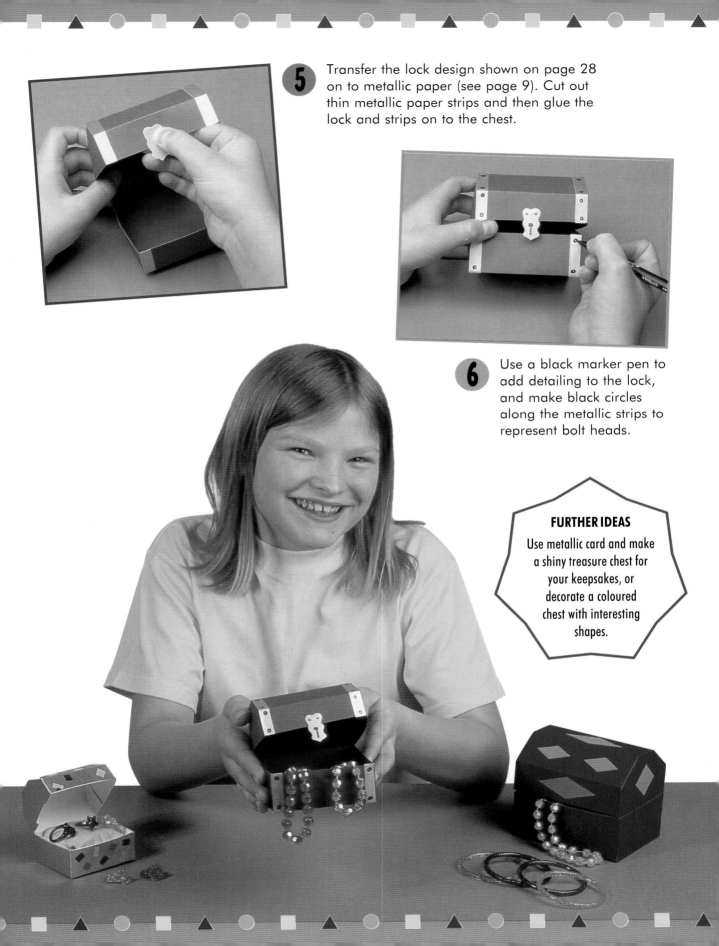

5 Transfer the lock design shown on page 28 on to metallic paper (see page 9). Cut out thin metallic paper strips and then glue the lock and strips on to the chest.

6 Use a black marker pen to add detailing to the lock, and make black circles along the metallic strips to represent bolt heads.

FURTHER IDEAS

Use metallic card and make a shiny treasure chest for your keepsakes, or decorate a coloured chest with interesting shapes.

Elephant Mask

Everyone loves masks. They are great fun to make and wear and they can transform you into something, or someone, completely different. This project is easy to do and it can be adapted if you want to create a different animal.

YOU WILL NEED

Thin black card
Thin coloured card • Tracing paper
Carbon paper • Masking tape
Pencil • Stapler
Empty ballpoint pen • Ruler
Scissors • Craft knife
Cutting mat

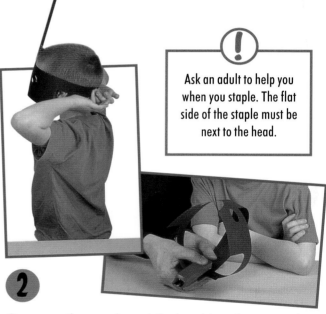

! Ask an adult to help you when you staple. The flat side of the staple must be next to the head.

1 Cut out a piece of thin black card approximately 70cm x 50cm (27½in x 19¾in). Fold the card in half widthways, then align the marked edge of the basic mask pattern on page 30 along the fold. Transfer the pattern on to the card (see page 9), then cut out the shapes.

2 Open up the mask and fit the side tabs around your head. Hold them in position, remove the mask then staple the ends. Replace the mask on your head and take the front strip over the top of your head. Hold in position, remove and staple in place.

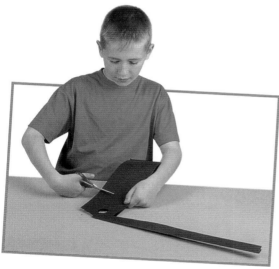

3 Transfer the face, ears and trunk patterns on pages 30 and 31 on to thin coloured card. Cut them out. Score along the fold lines of the trunk (see page 8) and then form it into pleats.

4 Use scissors to cut out the eye holes. Use a craft knife to cut a slit in the face where the trunk goes. Insert the trunk into the slit and tape in place.

Craft knives are sharp. Ask an adult to cut the slit in the trunk.

FURTHER IDEAS

You can adapt the pattern and use different coloured card to make a pig mask.

5 Fold the ears along the fold lines then ask an adult to staple them to the sides of the basic mask.

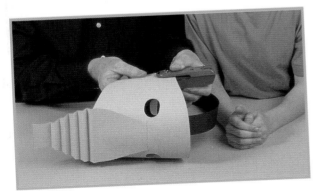

6 Ask an adult to attach the face to the basic mask with staples, making sure the eyes line up.

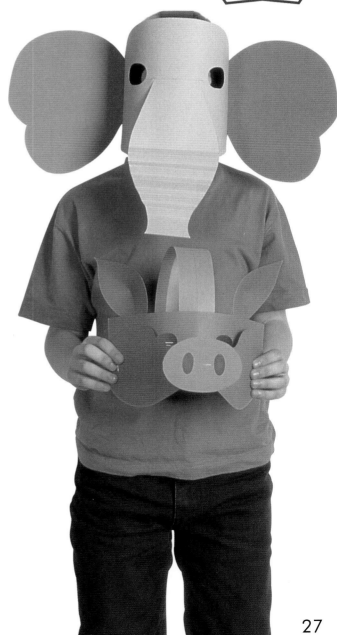

27

Patterns

Enlarge these patterns on a photocopier by 200%, then use them to make the templates for the projects (see page 9).

The patterns show two types of fold. Sometimes you need to fold the paper away from you. These folds are called valley folds. They are shown as dots and dashes. When you fold towards you, it's called a mountain fold. These folds are shown as dashes.

—·—·—·—·—·—·—·—·— *Valley fold – fold away from you*

- - - - - - - - - - - - - - - *Mountain fold – fold towards you*

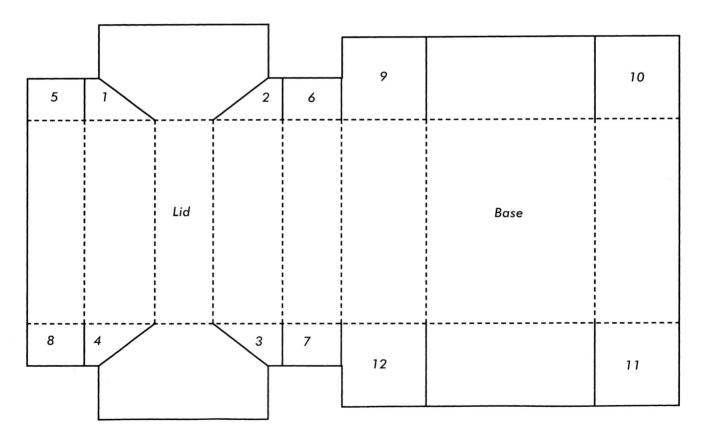

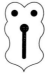

Patterns for the Treasure Chest featured on pages 24–25.

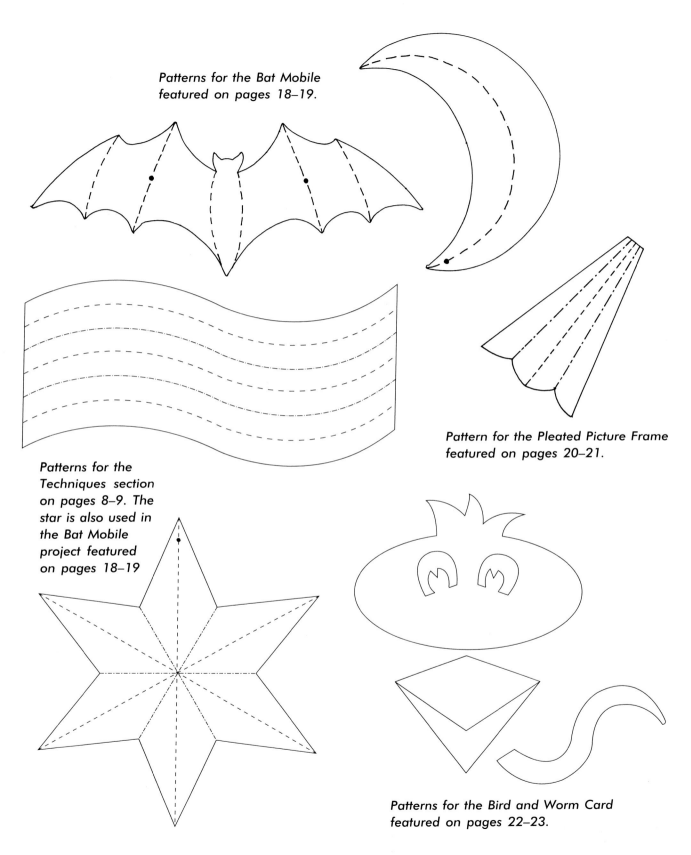

Patterns for the Bat Mobile featured on pages 18–19.

Pattern for the Pleated Picture Frame featured on pages 20–21.

Patterns for the Techniques section on pages 8–9. The star is also used in the Bat Mobile project featured on pages 18–19

Patterns for the Bird and Worm Card featured on pages 22–23.

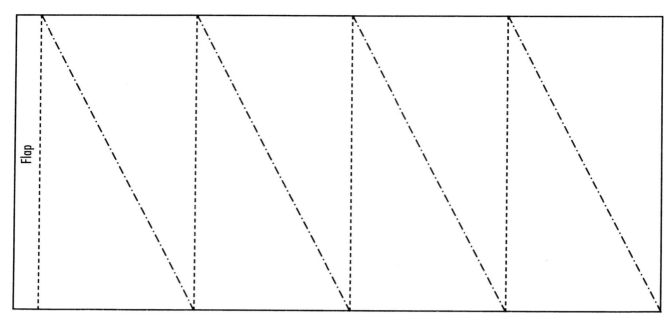

Flap

*Pattern for the Twisted Pot
featured on pages 16–17.*

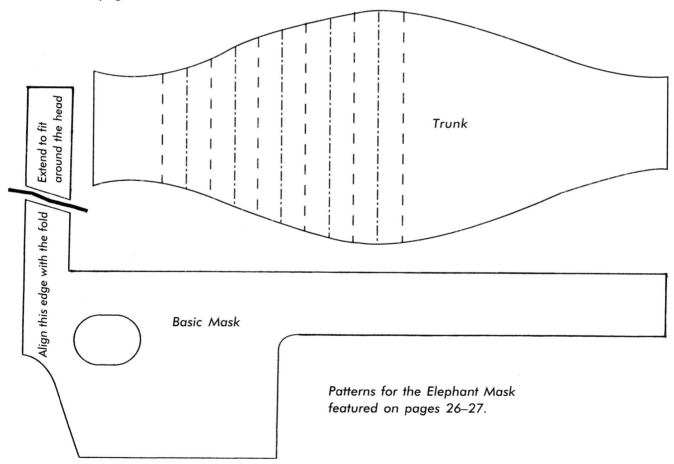

Extend to fit around the head

Align this edge with the fold

Trunk

Basic Mask

*Patterns for the Elephant Mask
featured on pages 26–27.*

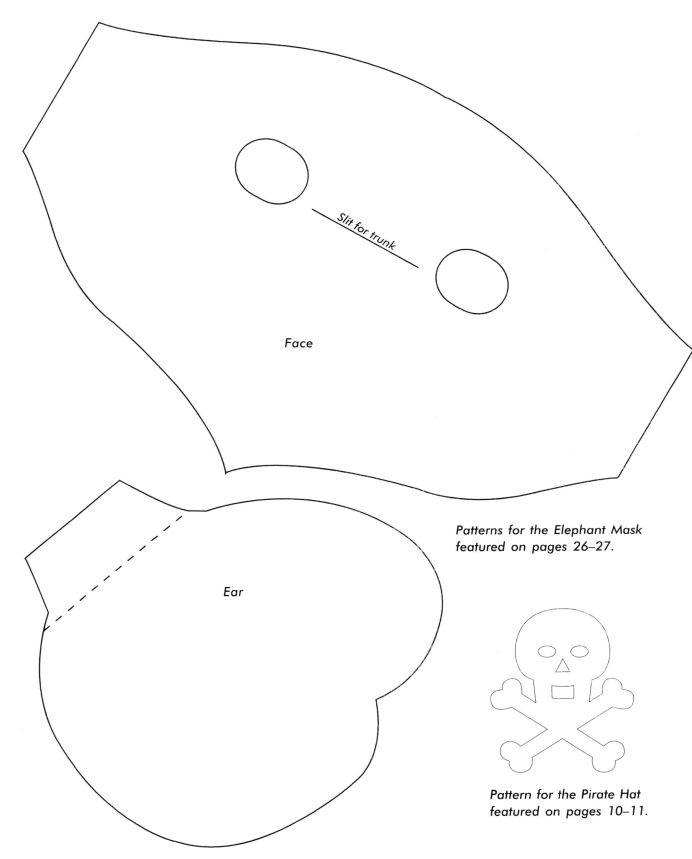

Face

Slit for trunk

Ear

Patterns for the Elephant Mask
featured on pages 26–27.

Pattern for the Pirate Hat
featured on pages 10–11.

Index